Creepy Crawlies
grayscale coloring book

by
Tabz Jones

©TabzJones

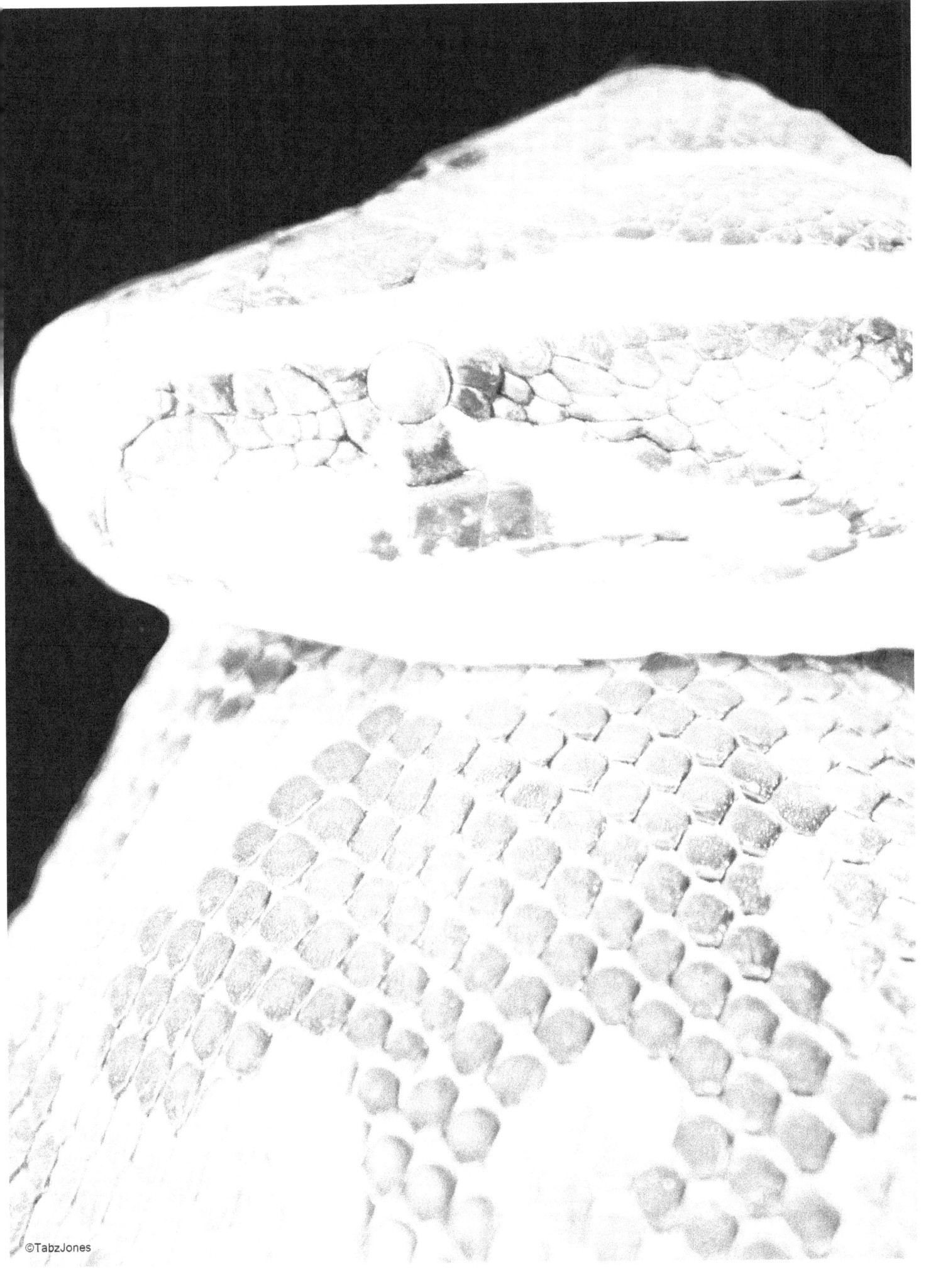

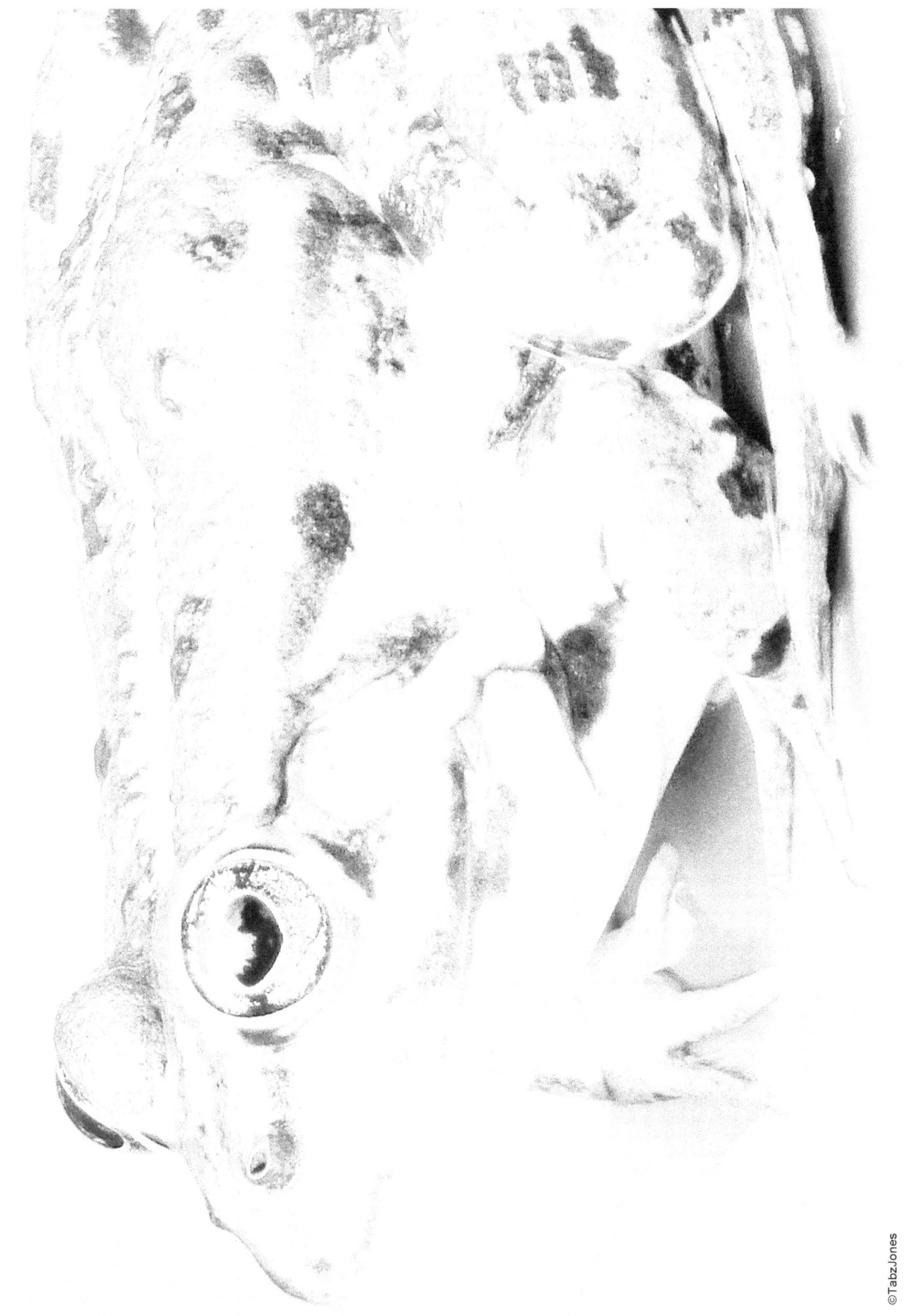

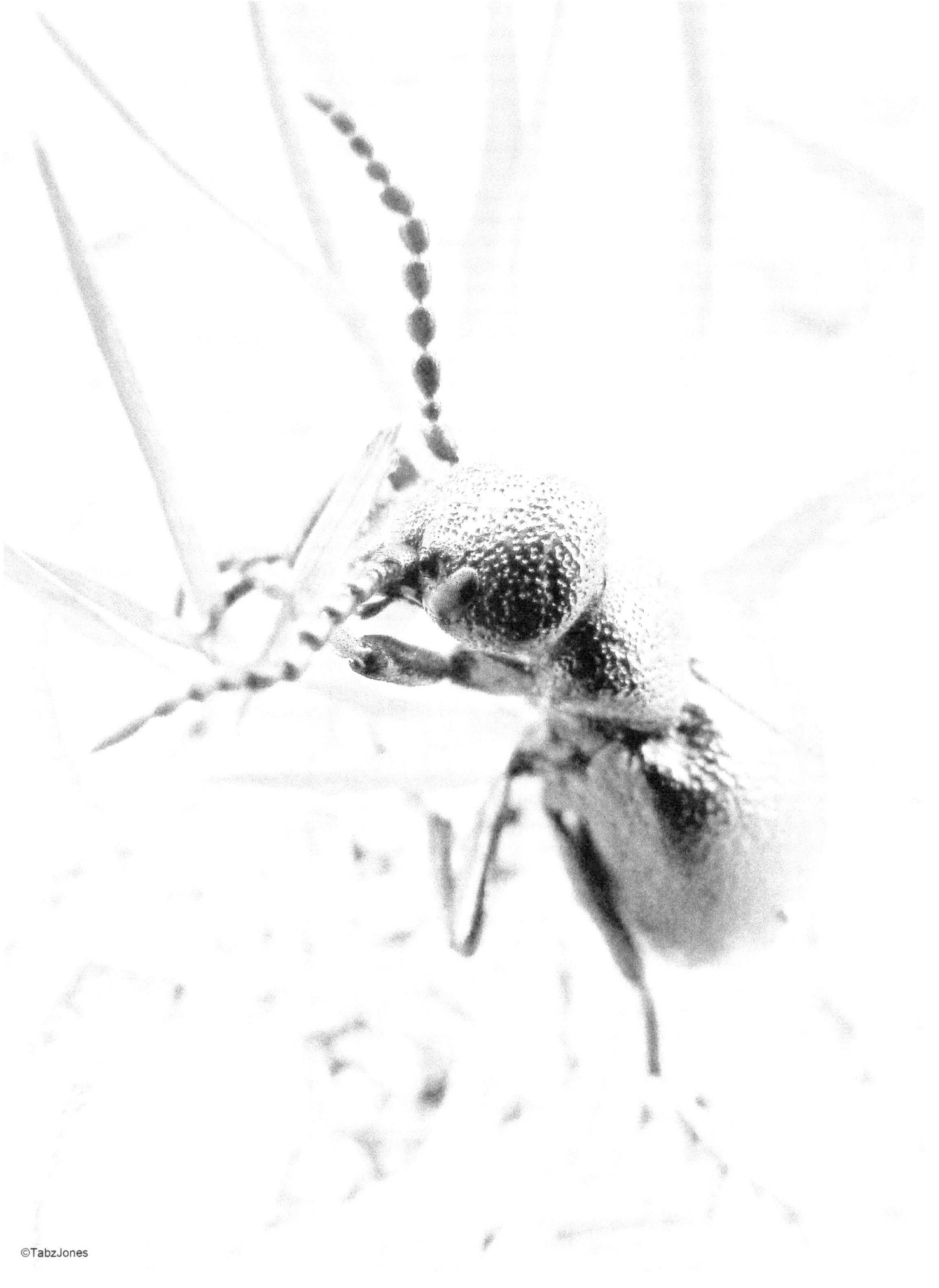

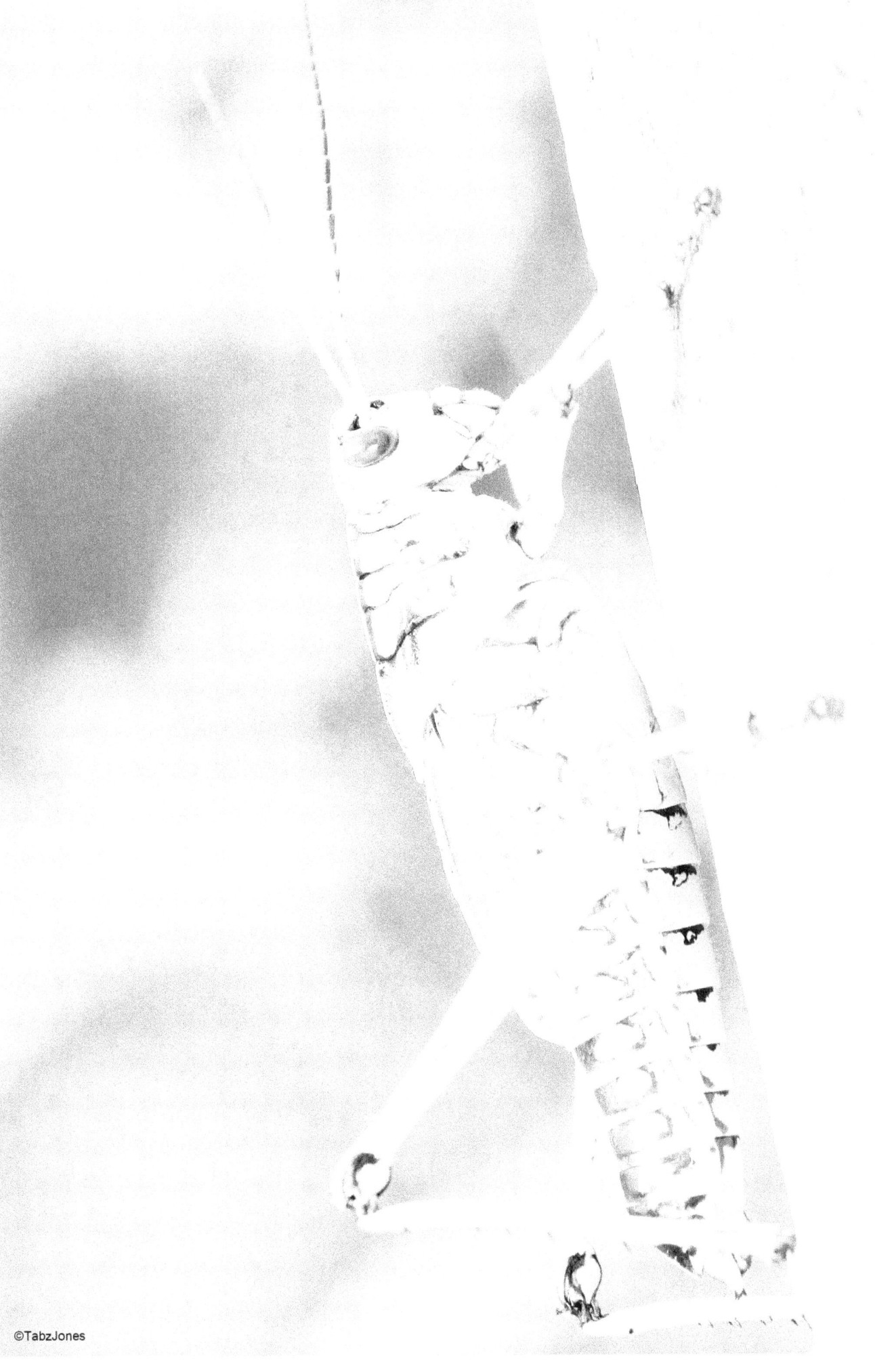

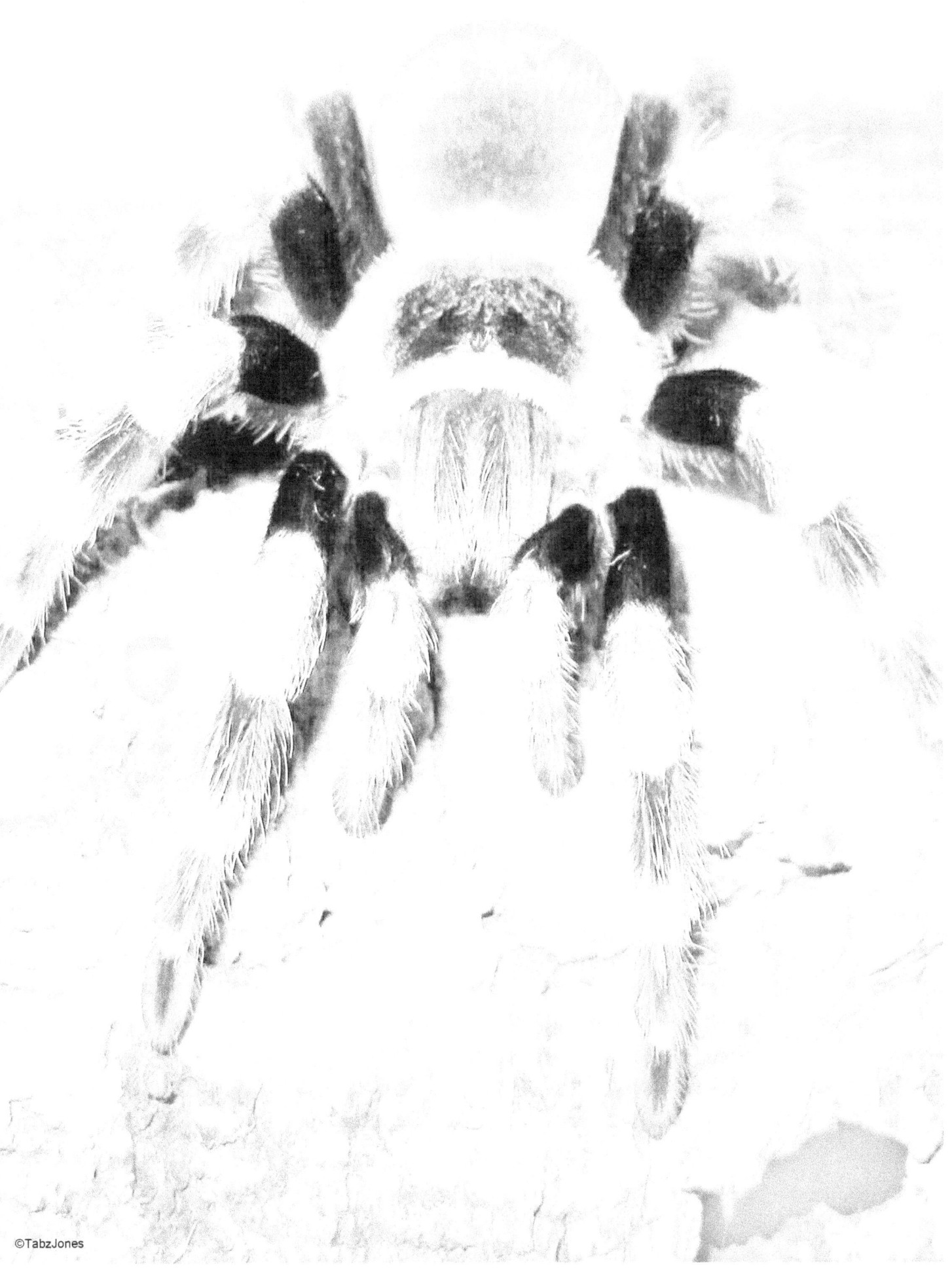

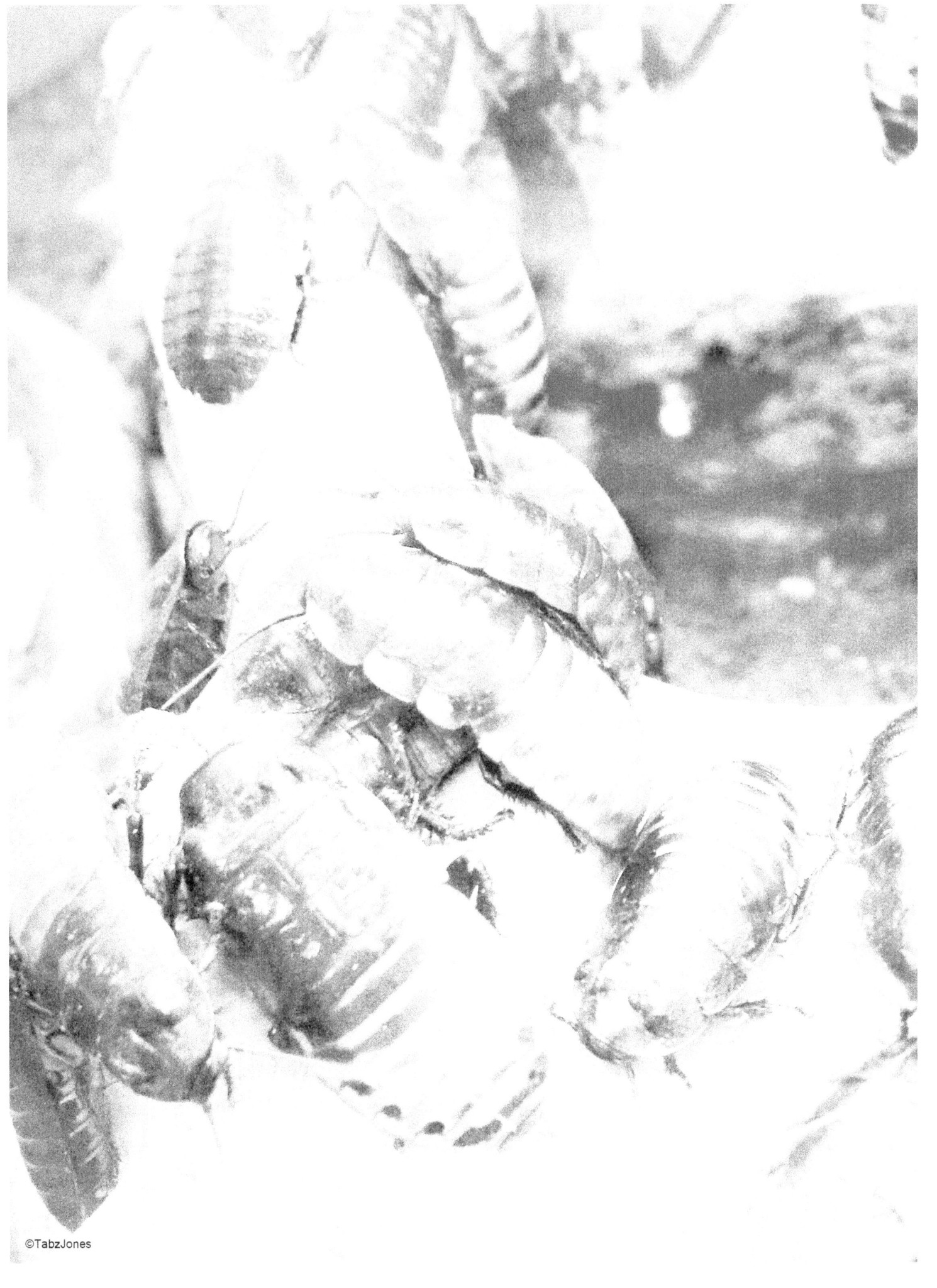

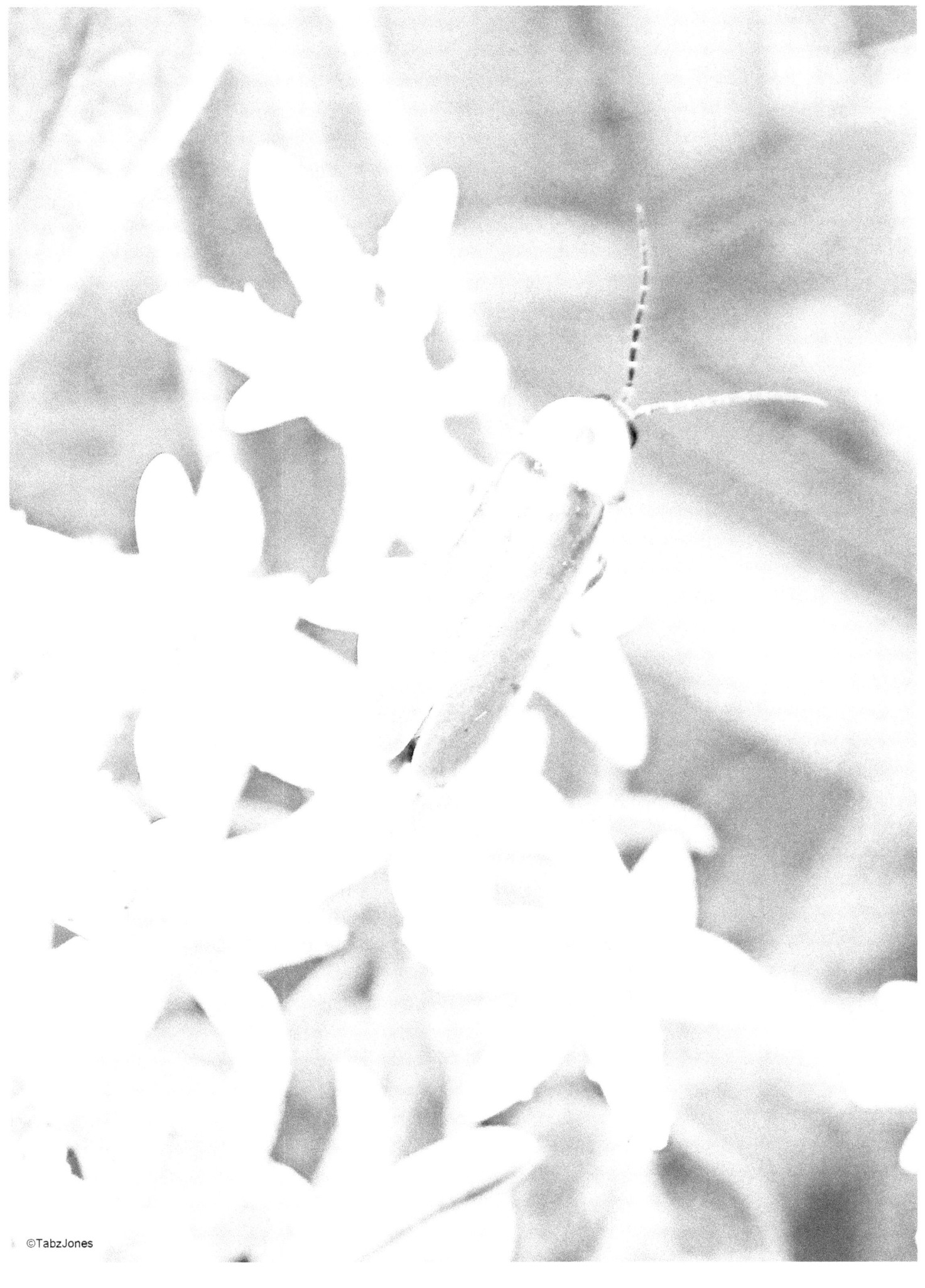

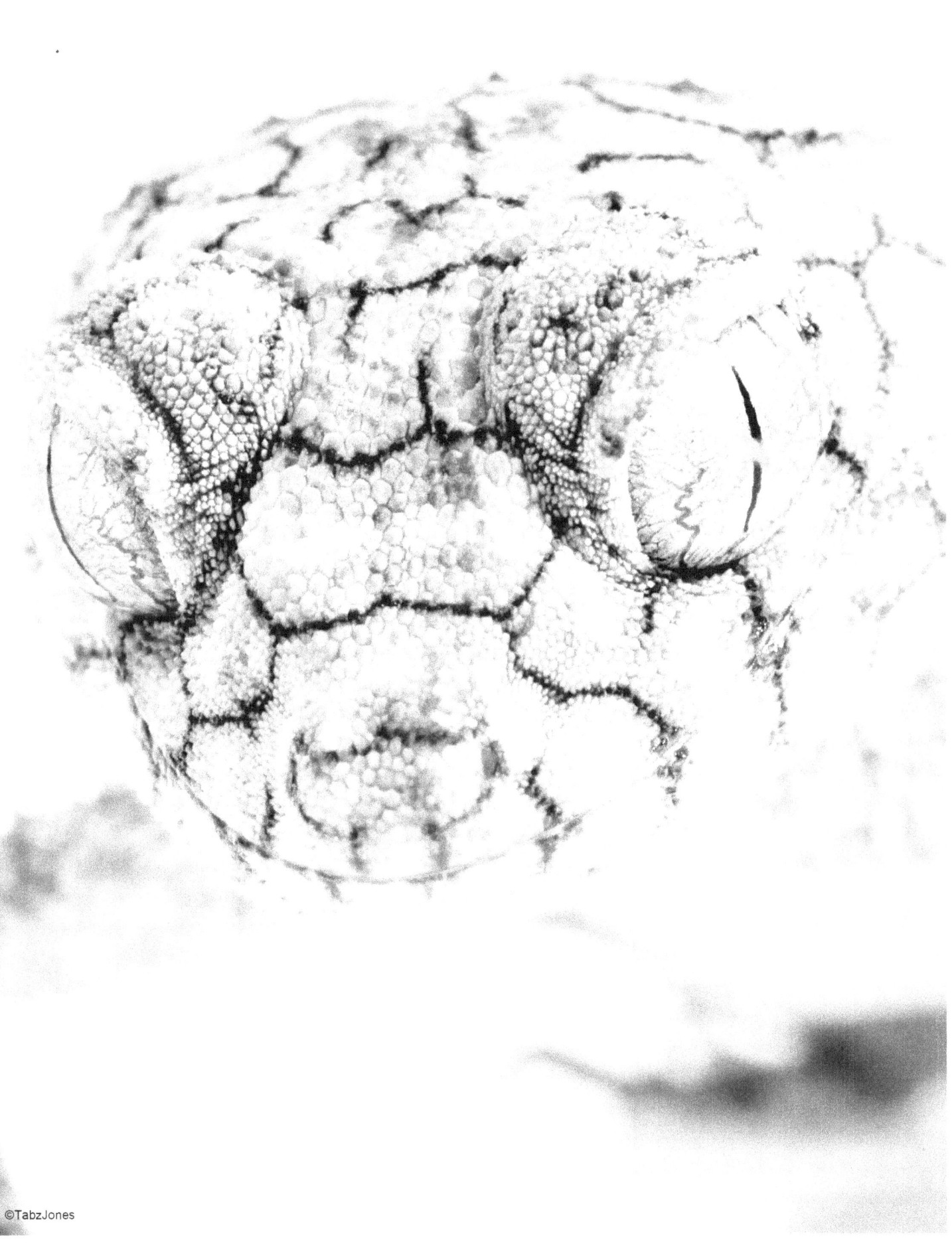

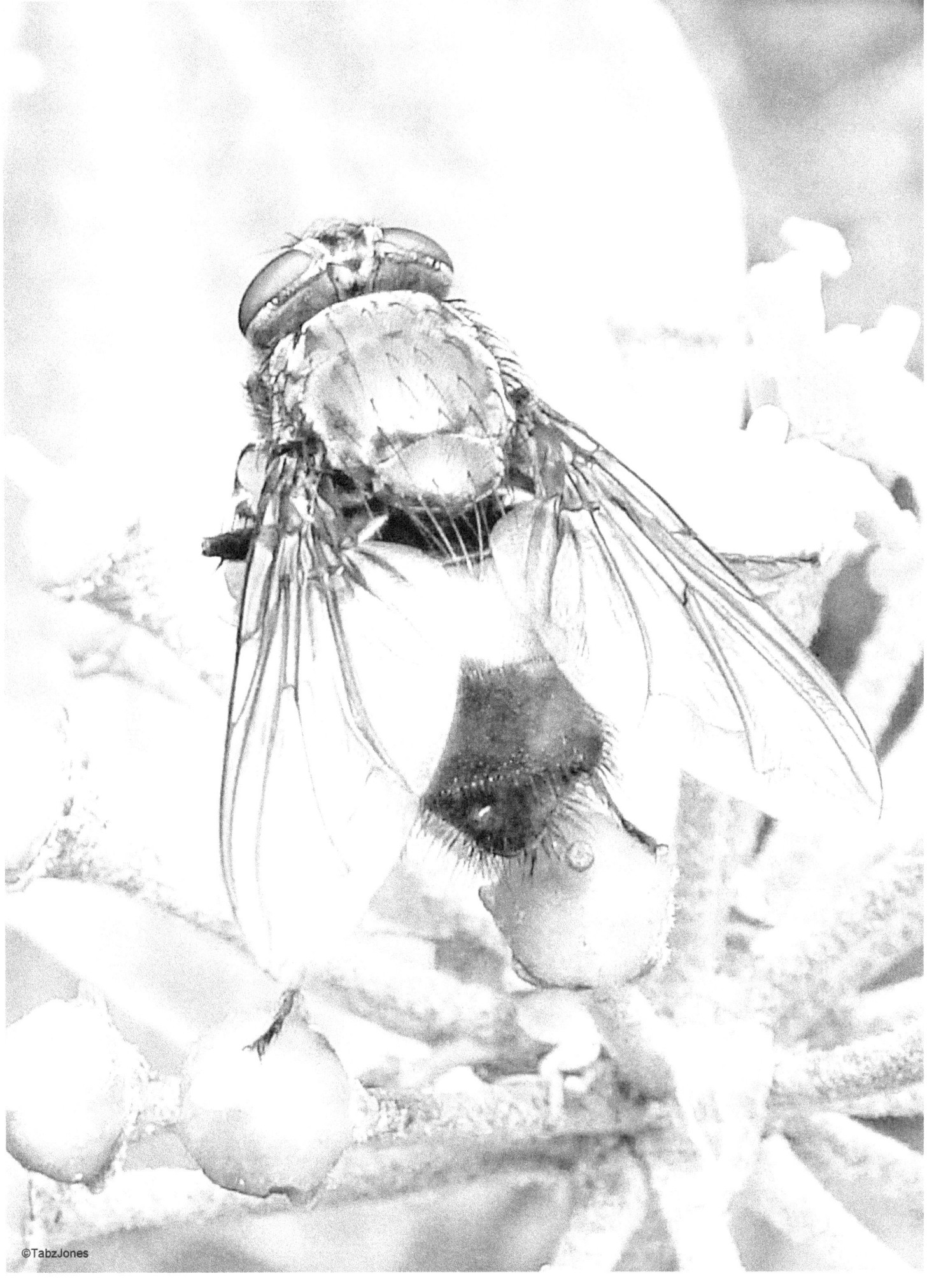

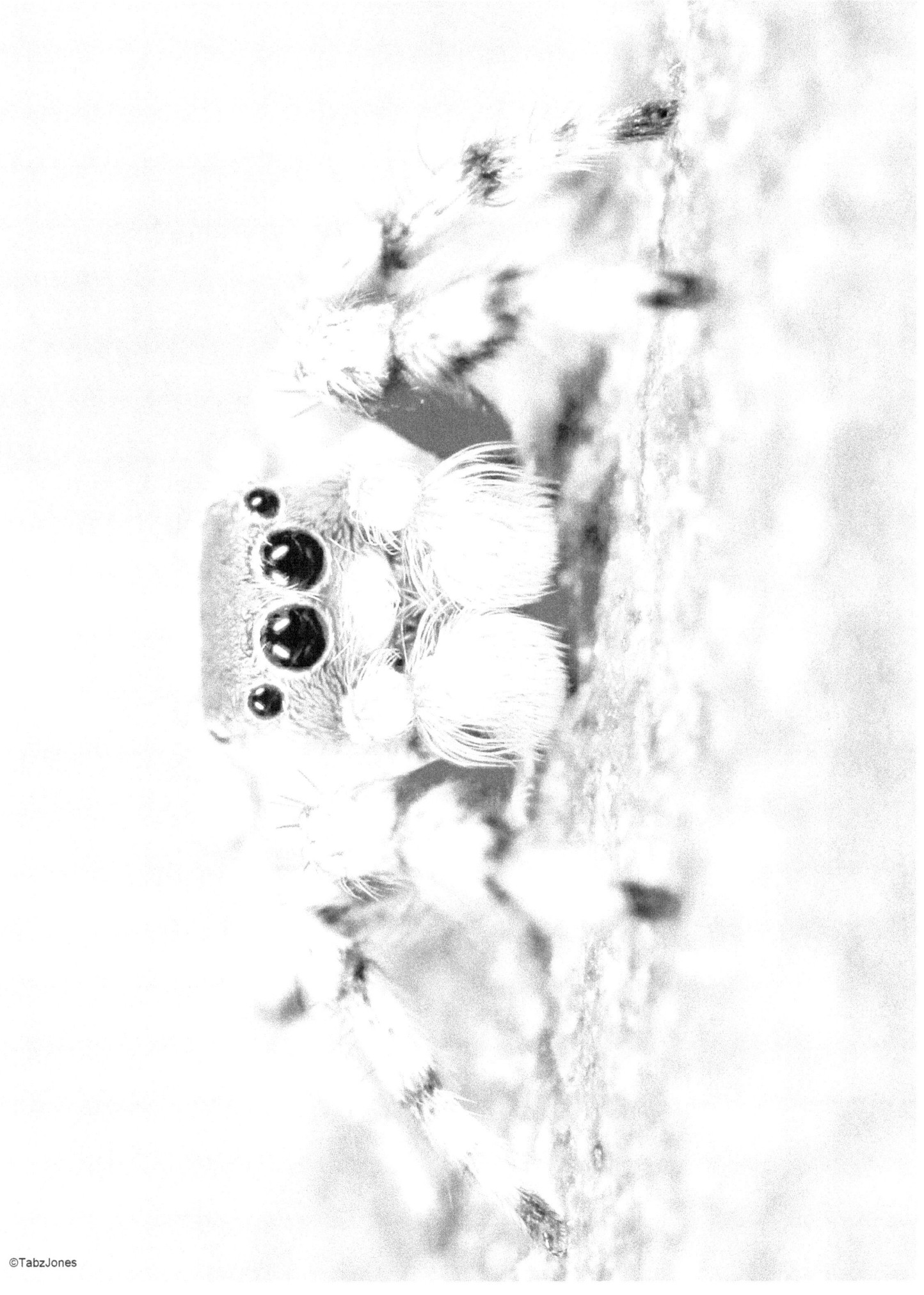

©TabzJones

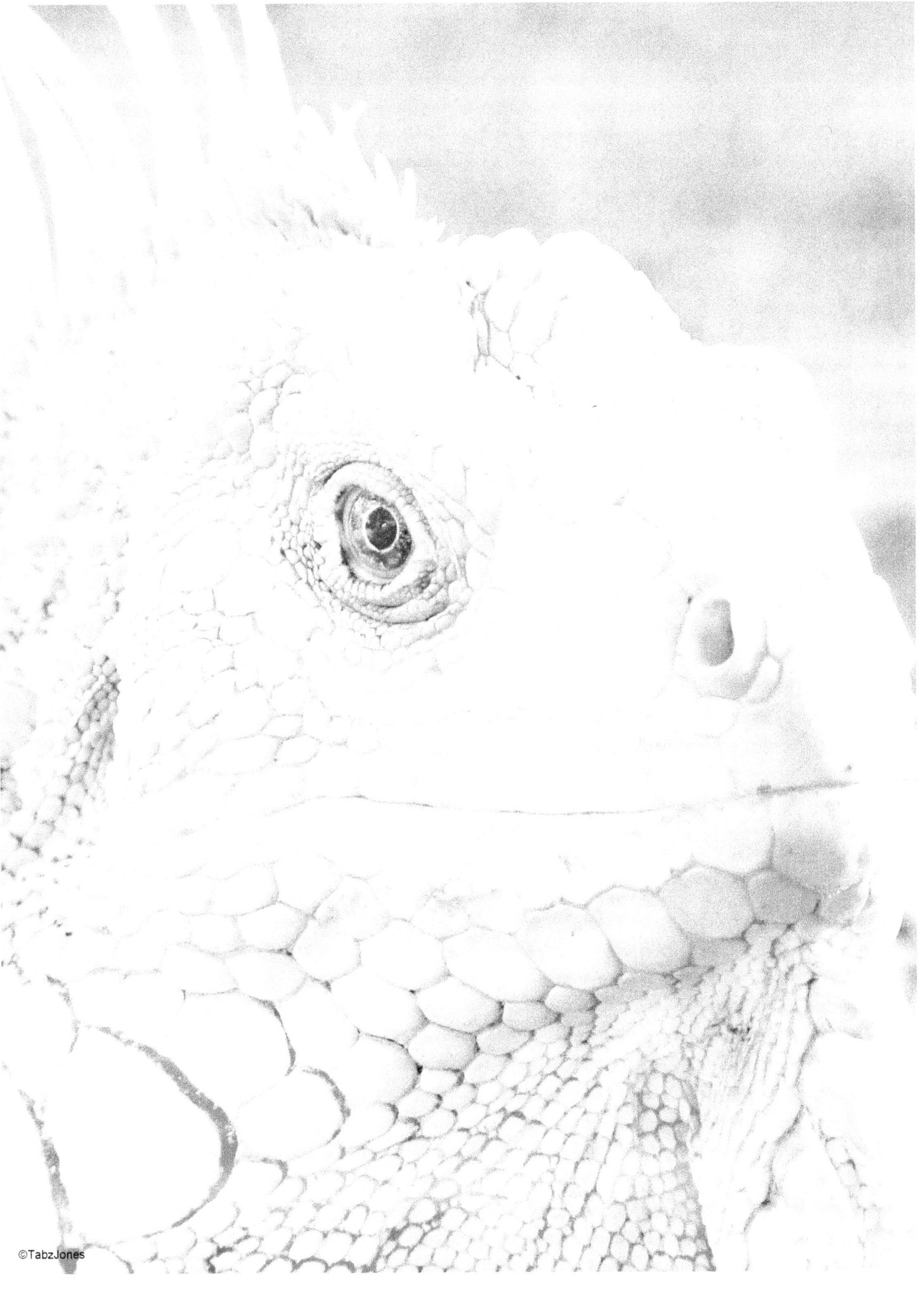

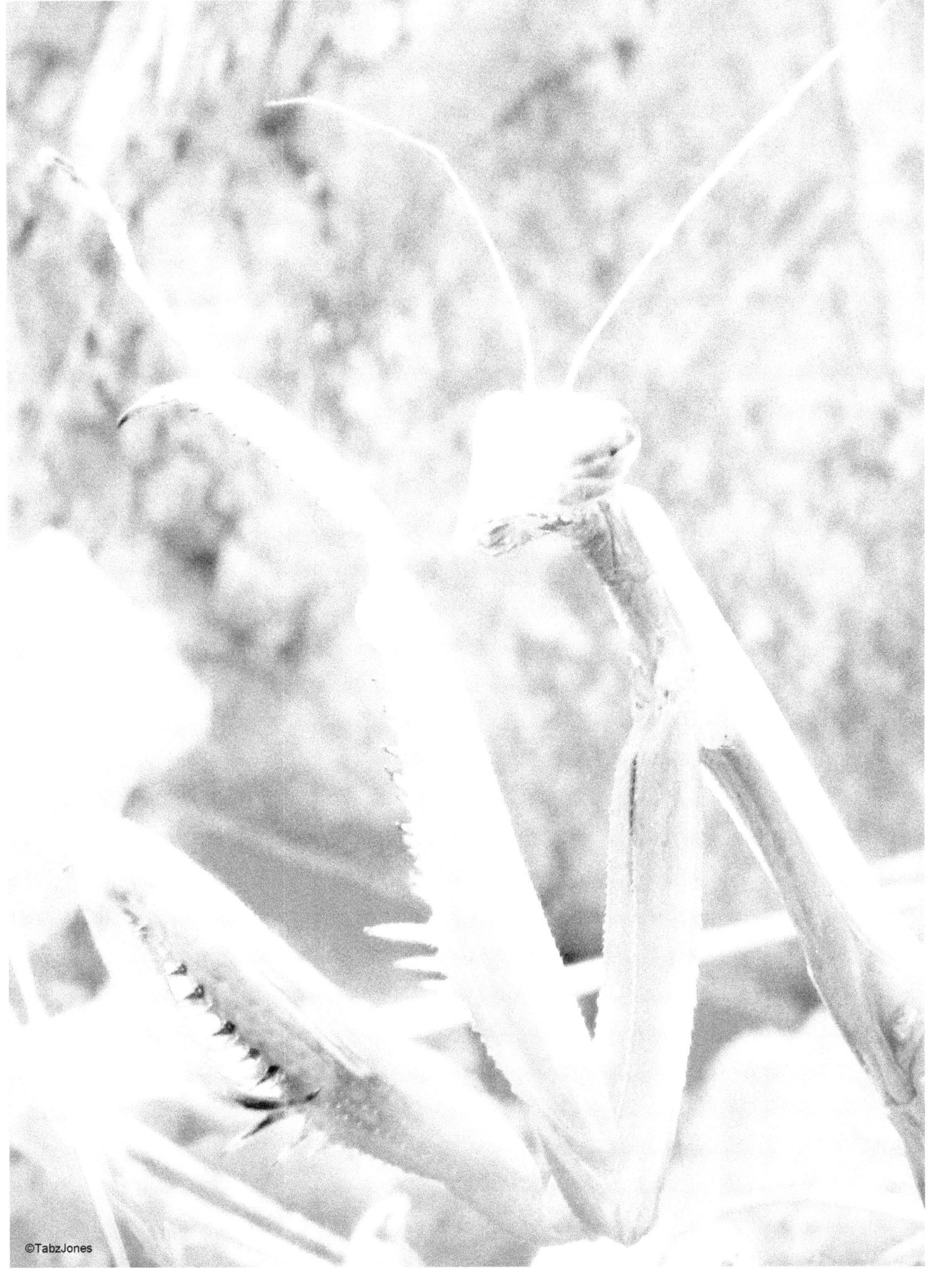

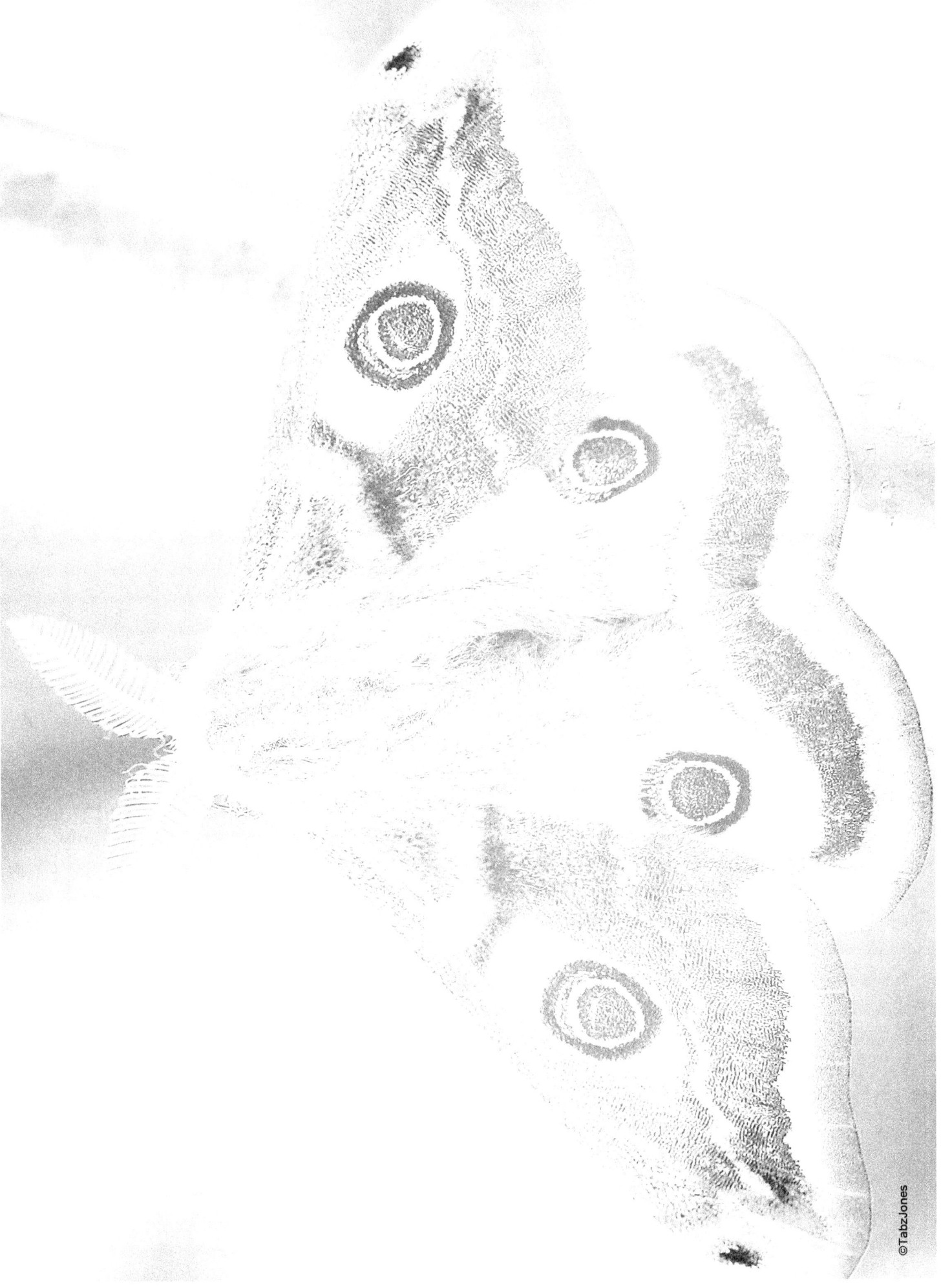

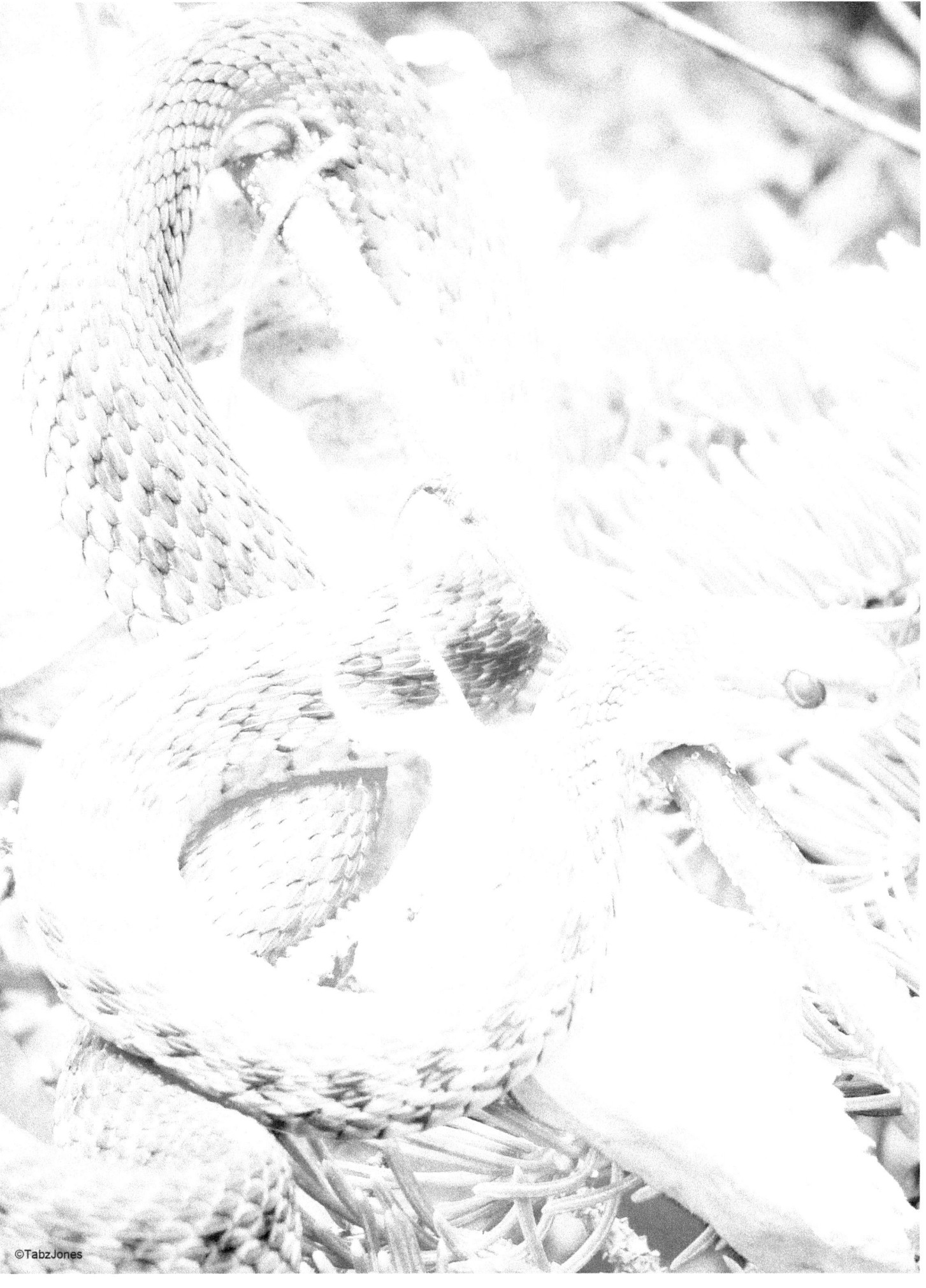

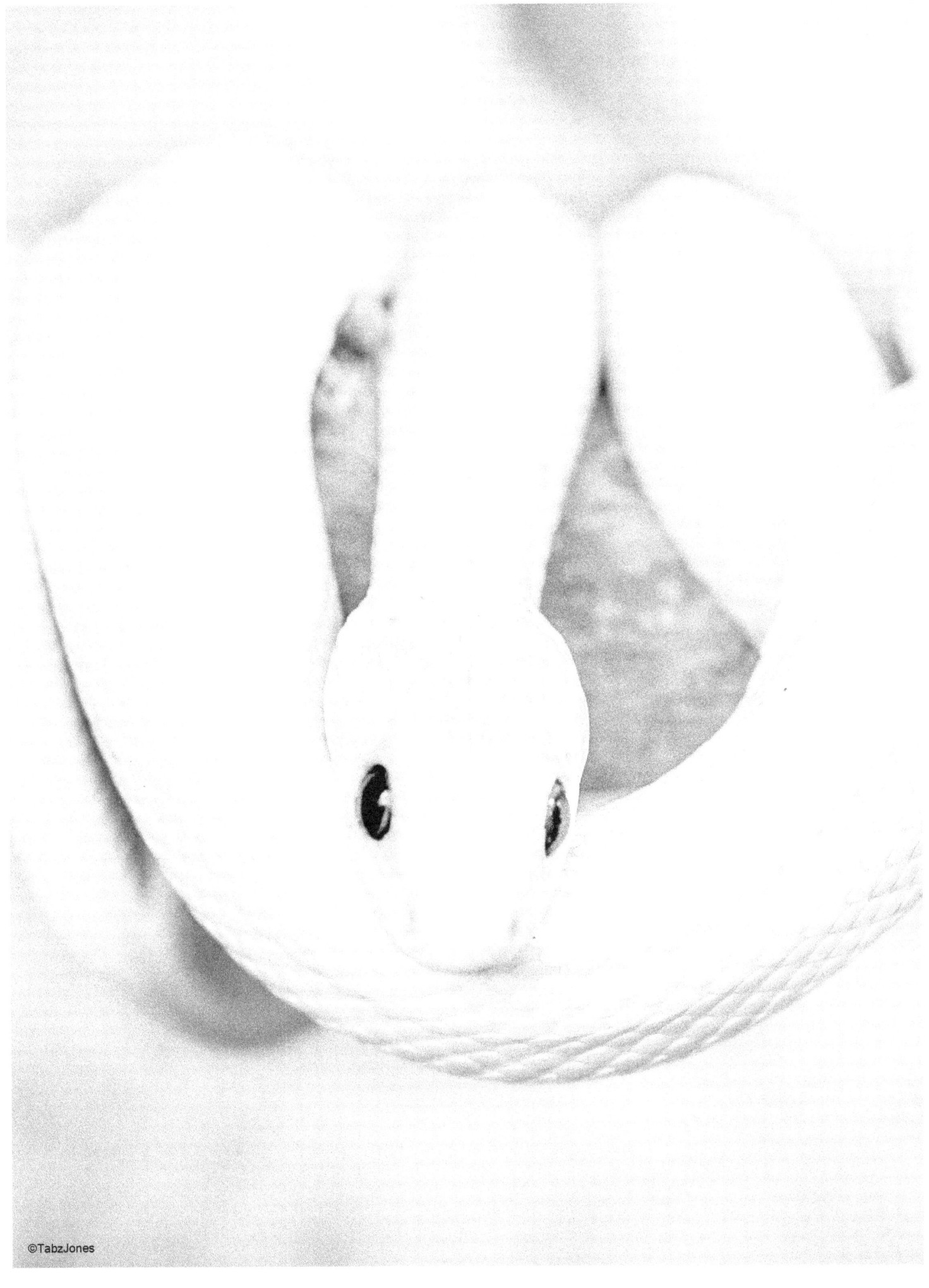

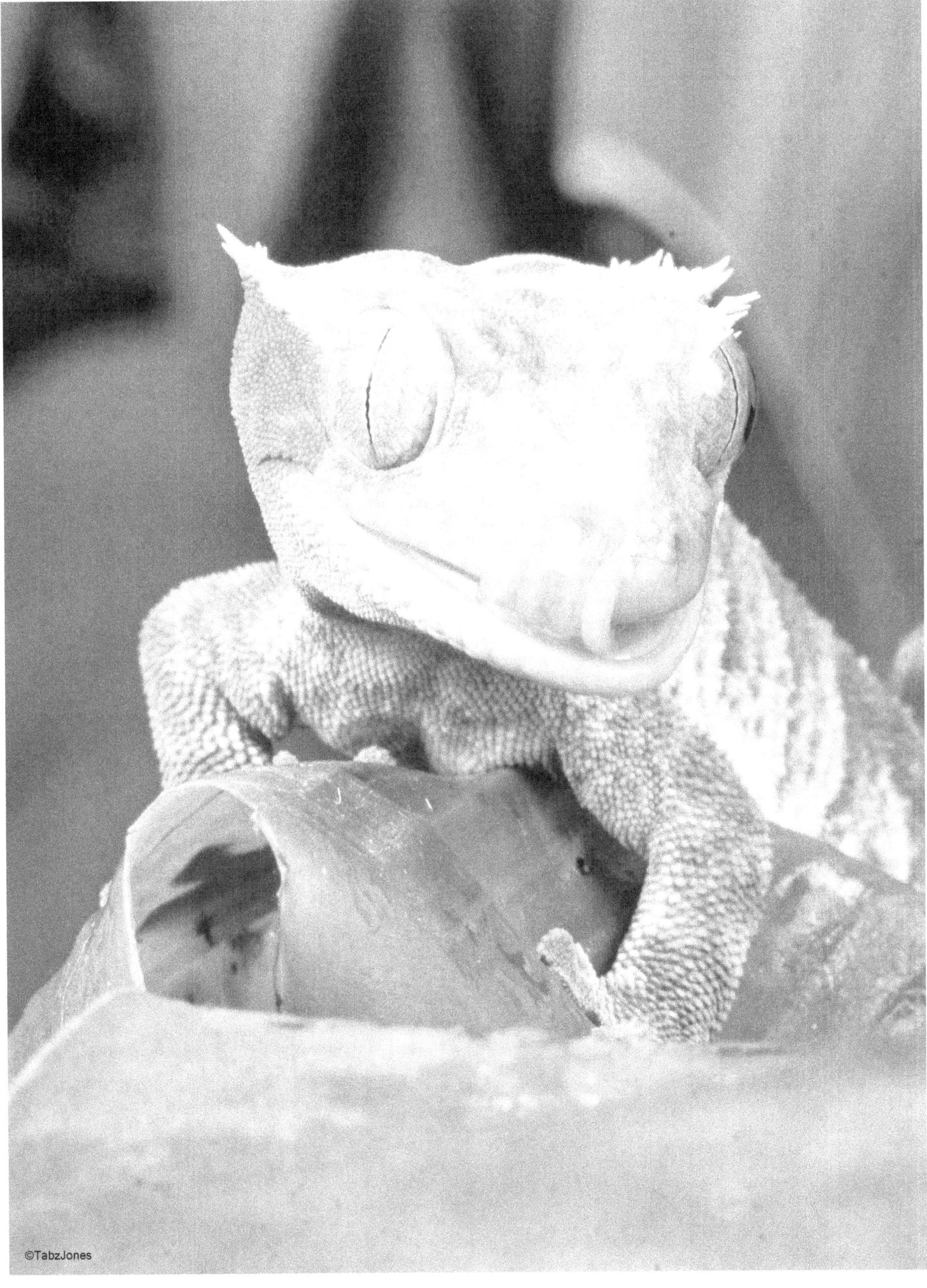

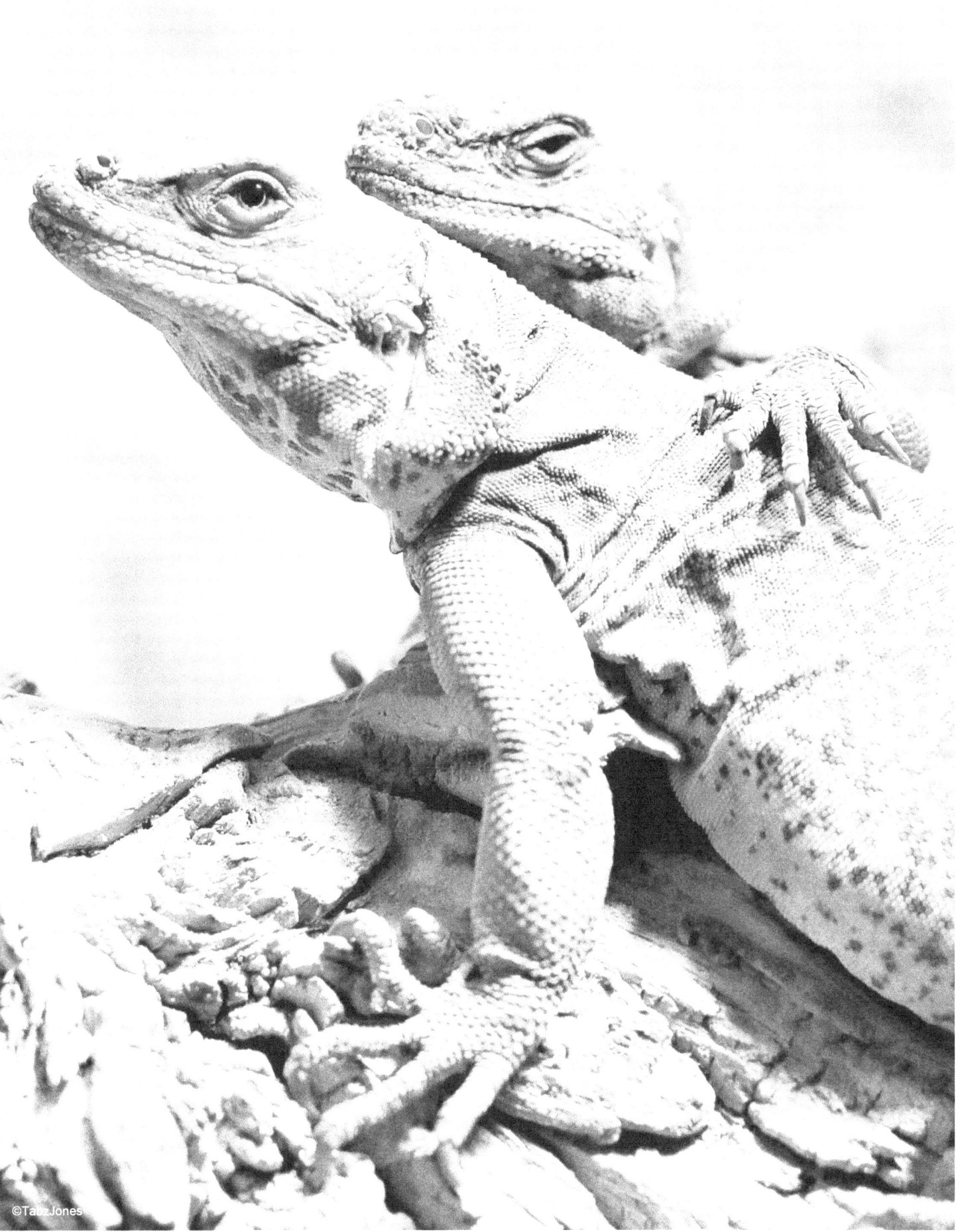

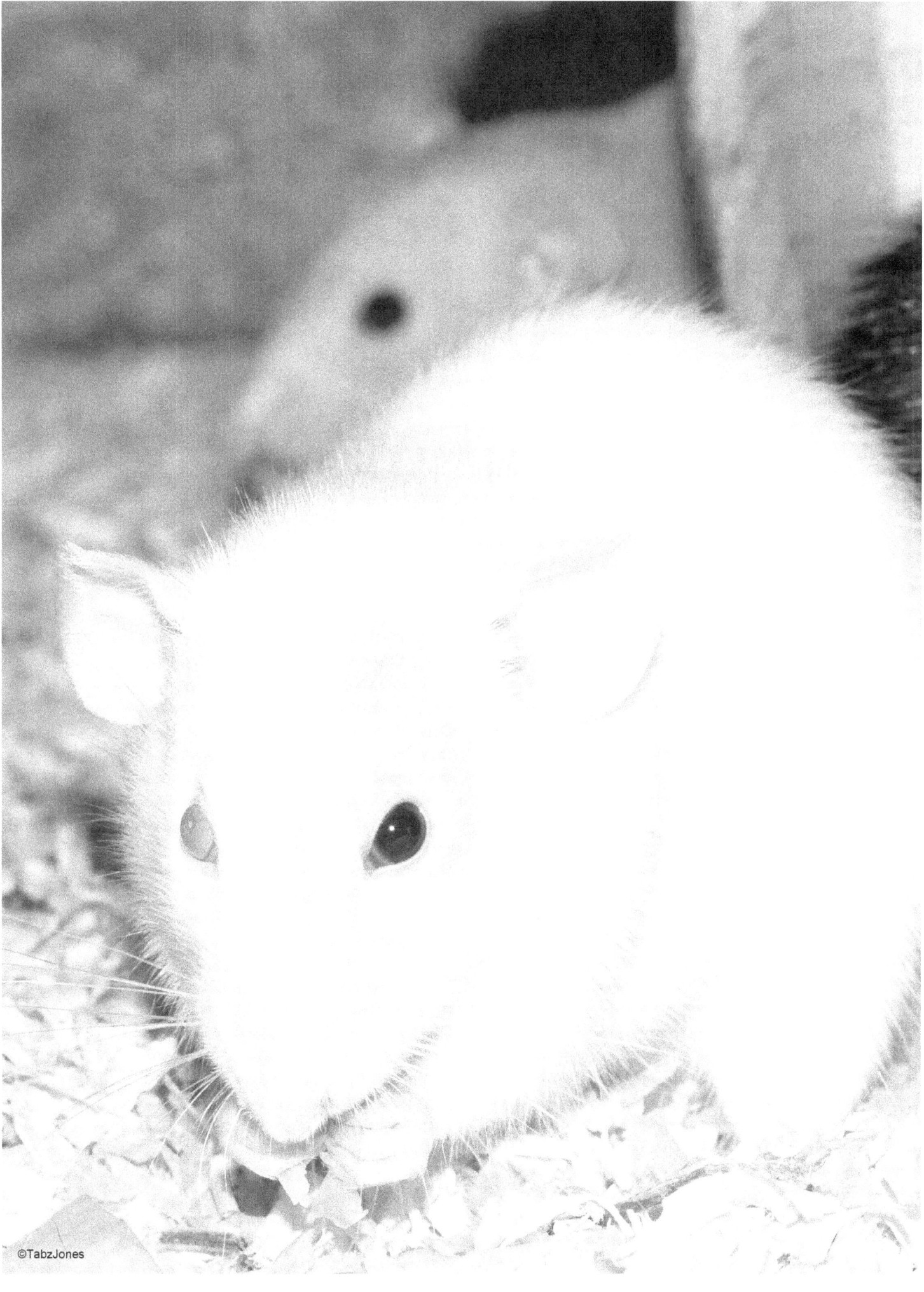

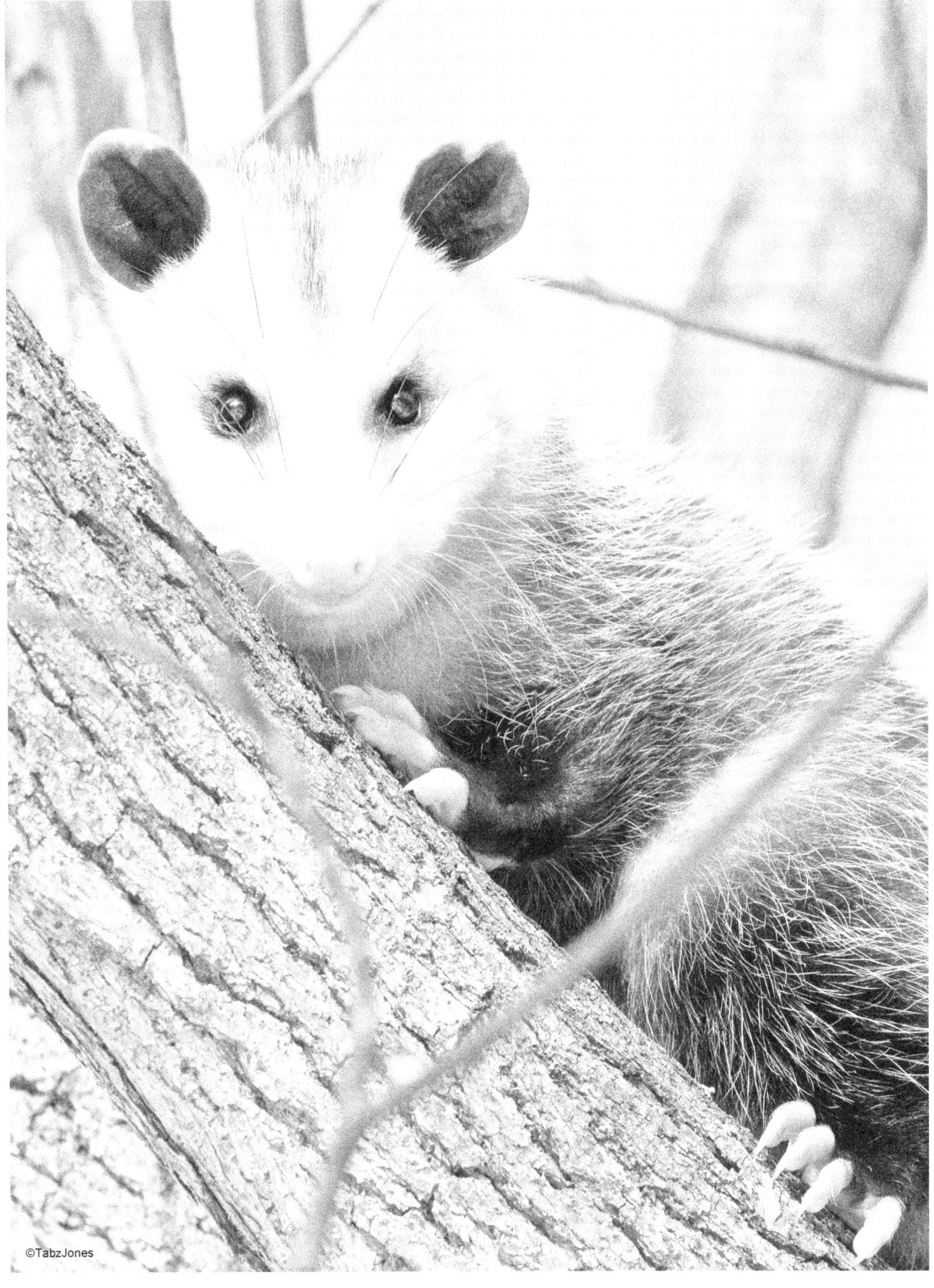

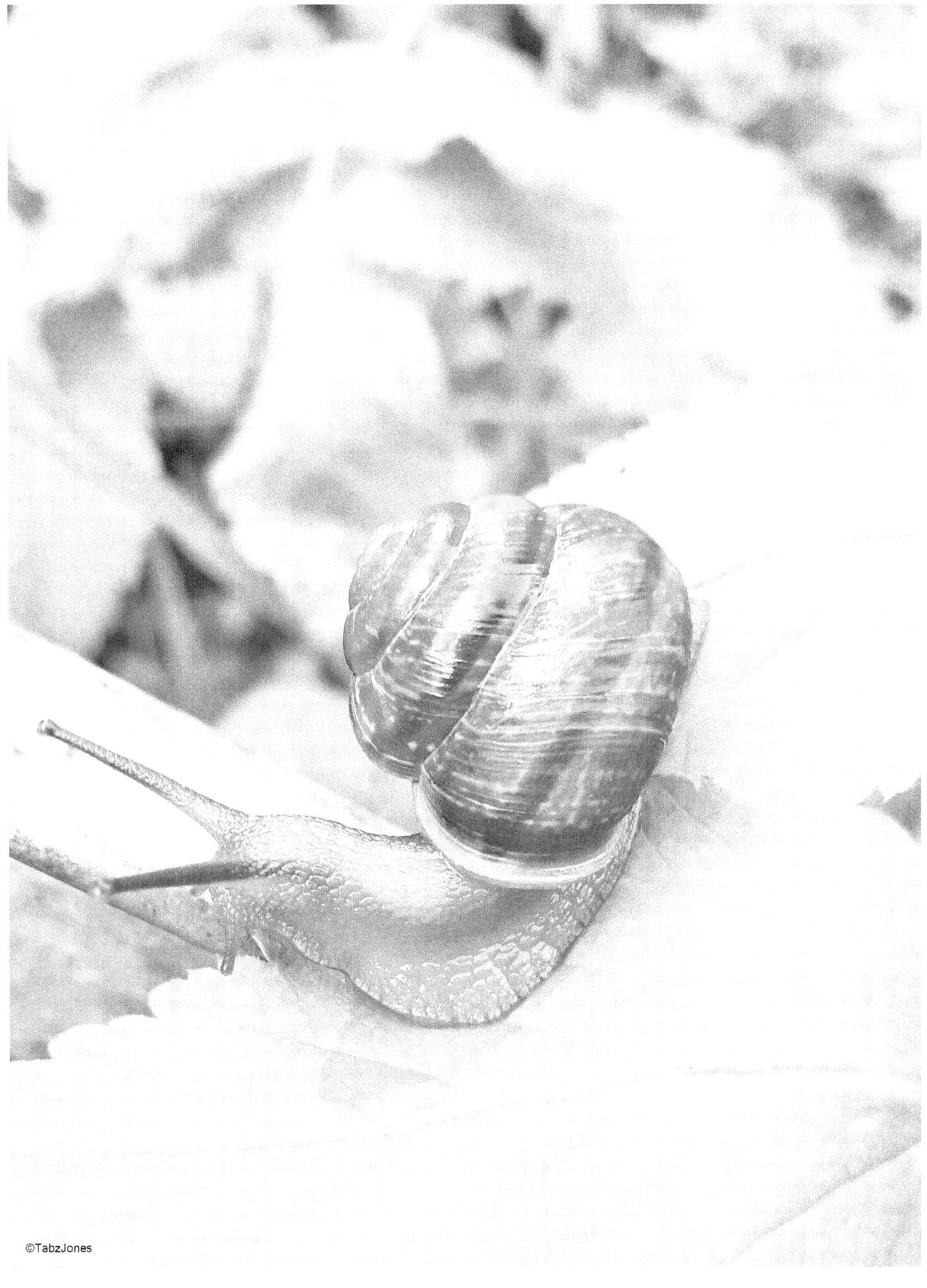

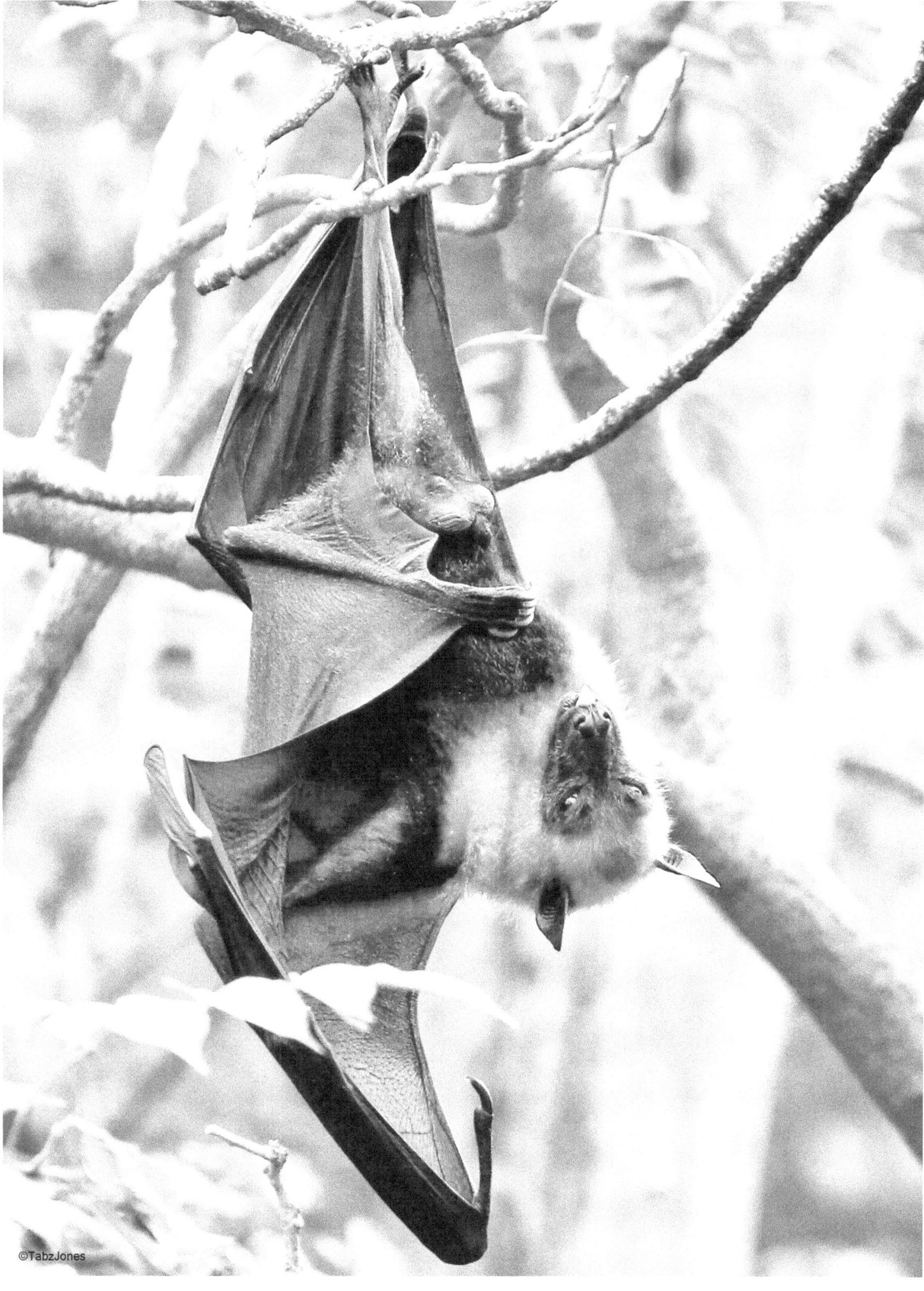

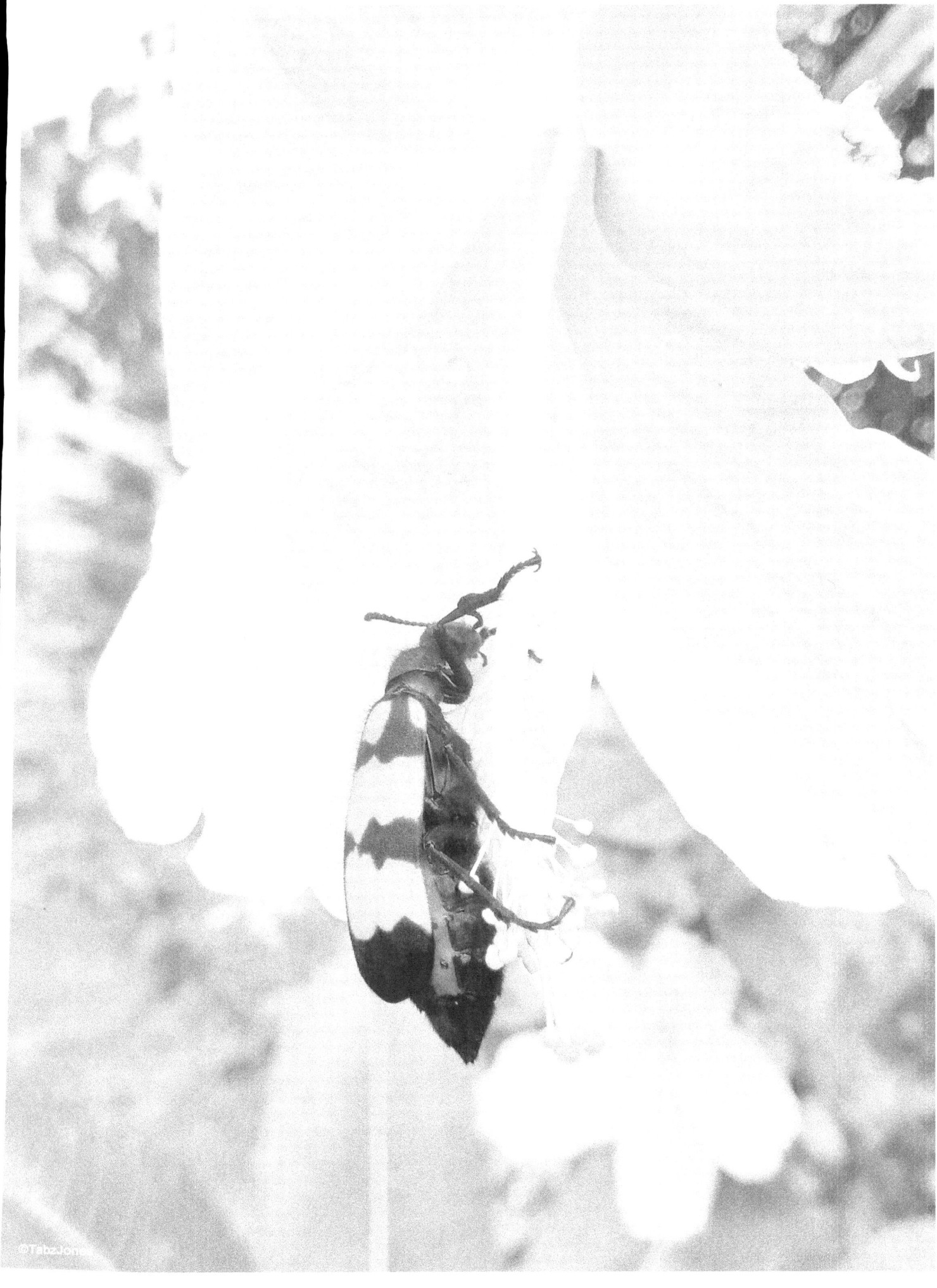

www.ingramcontent.com/pod-product-compliance
Lightning Source LLC
Chambersburg PA
CBHW080137240526
45468CB00009BA/2509